Handmade
Oriental Cards

Polly Pinder

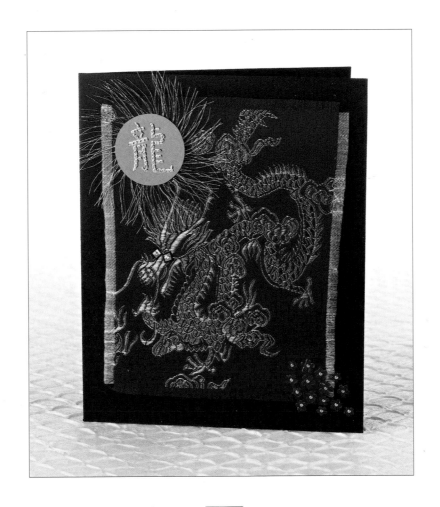

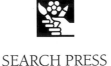

SEARCH PRESS

First published in Great Britain 2007

Search Press Limited
Wellwood, North Farm Road,
Tunbridge Wells, Kent TN2 3DR

Text copyright © Polly Pinder 2007

Photographs by Charlotte de la Bédoyère at Search Press Studios
and Roddy Paine Photographic Studio

Photographs and design copyright © Search Press Ltd 2007

ISBN-10: 1-84448-210-3
ISBN-13: 978-1-84448-210-8

The Publishers and author can accept no responsibility for any
consequences arising from the information, advice or instructions
given in this publication.

Readers are permitted to reproduce any of the items in this book
for their personal use, or for the purposes of selling for charity, free
of charge and without the prior permission of the Publishers. Any
use of the items for commercial purposes is not permitted without
the prior permission of the Publishers.

Suppliers

If you have difficulty in obtaining any of the materials and
equipment mentioned in this book, then please visit the Search
Press website for details of suppliers: www.searchpress.com

Publisher's note

All the step-by-step photographs in this book feature the
author, Polly Pinder, demonstrating how to make oriental
greetings cards. No models have been used.

Dedication

I would like to dedicate this book to Alison and Mark. Alison
has the biggest collection of beads, ever – and generously
allows me to pilfer them at will. Mark is my chicken guru. He
gives enthusiastic help and advice when I am anxious about
the welfare of my little hens.

Acknowledgements

I would like to thank the following companies whose
products have been used in this book.
Hero Art; Anita's Stamps; Hobbycraft (paper crimper);
Aitoh Japanese Origami Papers; Abracardabra Tattoos;
Anita's Outline Stickers; Fiskars (embossing tools);
Pergamano (perforating tools); Marabu (outline paste);
Pebeo and Miree (glass paints); Fred Aldous for supplies
online; and Brass Stencil Classics.

Cover: The Moon beyond the Leaves
*This card was inspired by one of a series of prints Twenty Eight
Views of the Moon by Hiroshige. The series combines elegant
visual studies and simple Japanese poetry.*

Page 1: Golden Dragon
*This beautiful card uses the collage techniques explained on
pages 40-43. The sumptuous fabric was an off cut found at my
local economy store. More details can be found on page 45.*

Contents

Introduction

The word 'oriental' conjures up so many wonderful images, from the simplicity of formal, understated Japanese designs to the opulence of intricate Chinese brocades. The characters of Far Eastern alphabets are in themselves miniature works of art – they can create exquisite emblems without the addition of any other mark, and can form an intrinsic part of a painting. In this book I have often combined the characters of one country with the designs or symbols of another, because visually they complement each other so beautifully.

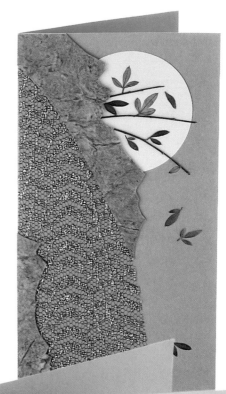

Designing and making greeting cards is, in my opinion, equal to making a painting or any other form of high art work. The same creative process is used – the initial excitement when a idea develops into a distinct possibility; then the actual making of the card, bringing all the different components together to form a single image; the wonderful satisfaction of completion, and finally (and this is something not often experienced in the making of a work of art) the grateful appreciation and effusive compliments from the recipient – we hope!

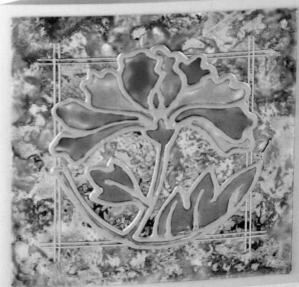

Many of the cards in this book have been copied from or inspired by images from the series of Design Source Books, also published by Search Press. These are simple line drawings which can easily be adapted or developed to suit your own ideas and techniques.

To any committed students of oriental languages: I have done my best to write the characters as accurately as possible and hope that the meaning is correct, but please accept my apologies if I have made conspicuous blunders. Thank you.

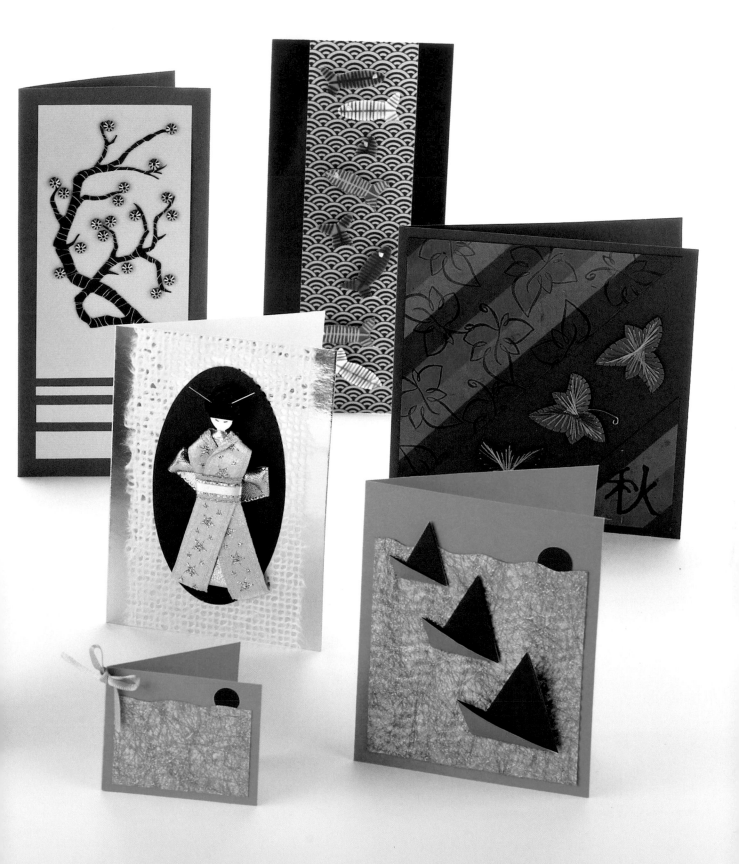

Materials

As a general crafter or cardmaker you will probably already have much of the equipment necessary to complete the projects in this book. Even if you are an absolute beginner you will no doubt have some of the materials, and the others are easy to find in your local craft shop, one of the huge craft superstores via mail order or the internet. You are in for a great treat because cardmaking is one of the most satisfying crafts to be involved with.

Basic materials

Always keep your **pencils** as sharp as possible; a blunt pencil produces poor work. **Felt-tip pens** can be bought from many stationers. **Circle** and **oval templates** are very useful, and although circles can be drawn with **compasses**, it is difficult trying to draw a perfect oval freehand. **Masking tape** and **sticky tape** are used to secure things temporarily but **double-sided sticky tape** is invaluable and probably the cleanest method of permanently attaching small, light objects. Items can also be attached with small **double-sided adhesive foam squares** which are used to raise sections of card or paper. A **glue stick** is used for gluing paper and **clear all-purpose glue** is good for real security when heavier pieces need attaching to the card. **Spray mount**, which is perfect for sticking down larger pieces of paper, must always be used in a well ventilated area and wearing a **mask** – the tiny droplets of glue can be breathed in and the lungs have no way of dispelling them. **Sharp-pointed scissors** are necessary for detailed cutting, **old scissors** are useful for cutting **wire** and a **circle cutter** (used on a **cutting mat**) will cut a perfect circle. I prefer to use a metal-handled **craft knife** for strength when cutting paper or card. This should be used in conjunction with a **steel ruler** and the cutting mat, all available from many art or craft stores. **Pliers** and **tweezers**, **cocktail sticks** and **adhesive putty** are used in the Plum Blossom project (pages 16–19). A **light box** is essential for embossing but a window during daylight hours makes a good substitute. A **wave press** can be use to make corrugated card.

Paper and card

As more papers and cards become available, we are almost spoilt for choice. There are the wonderfully textured handmade papers and tissues (such as mulberry tissue), ranging from subtle earthy shades to shocking vibrant colours; spun synthetic papers as fine as gossamer; bold metallic ones, crinkled and pleated; even moulded three-dimensional papers made from recycled materials. Do not forget all the bits of paper and card that we can recycle ourselves – such as sweet and chocolate wrappers, old gift wrap, and the sparkly and textured areas of used greeting cards.

Embellishments

Beautiful beads, fascinating threads, coloured wires, feathers, outline stickers, glittery fabrics, dried twigs and leaves: all are used as embellishments for the projects and other cards in this book. You may already have many of them in your craft box or drawer, but they are all easy to come by if you do not. You can even buy packets of little dried leaves without going through the long process of pressing them yourself.

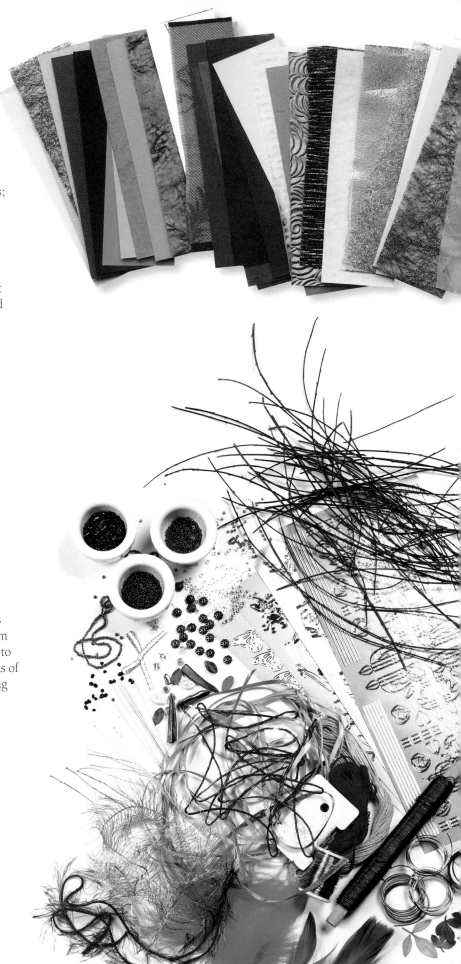

Glass paints, outline paste and acetate

These are all used in the Waves and Water project (pages 10–13) and are available from most craft stores. If you have not used them before, it is a good idea to practise beforehand. The process of outlining is very similar to using a nozzle when icing a cake. You will also need paint brushes and a bottle of solvent to clean them.

Craft punches and craft scissors

Craft punches now come in a comprehensive range of shapes and sizes but the old-fashioned hole punch is still very useful for producing a simple round hole. There are some really inventive craft scissors on the market which produce fascinating edges and corners for paper or thin card. Most craft outlets sell them. I find the cuticle scissors (available from chemists) are much easier to use than ordinary scissors when cutting curves.

Other materials

The stencils used for embossing and piercing are bought as little plates of perforated brass. These are perfect, but obviously the scope of design is limited to what is available. Homemade stencils can easily be cut from thin waxed card, available at some craft stores, and this widens the possibilities because you can create your own designs. The embossing tools, piercing needles (which come in a variety of arrangements) and the piercing mat are now available at most craft stores.

Other essential items for the card maker include various designs of craft stamp, used with different coloured ink pads. Tubes of glitter glue are also very useful. Make-up sponges, which can be bought from the chemist, are used to soften or smudge pastel pencil after it has been applied to an embossed image.

Glitter thread can be used to decorate your work, and is used in the Pine and Blossom project (pages 34–37). Netting is used in The Moon Beyond the Leaves project (pages 40–43).

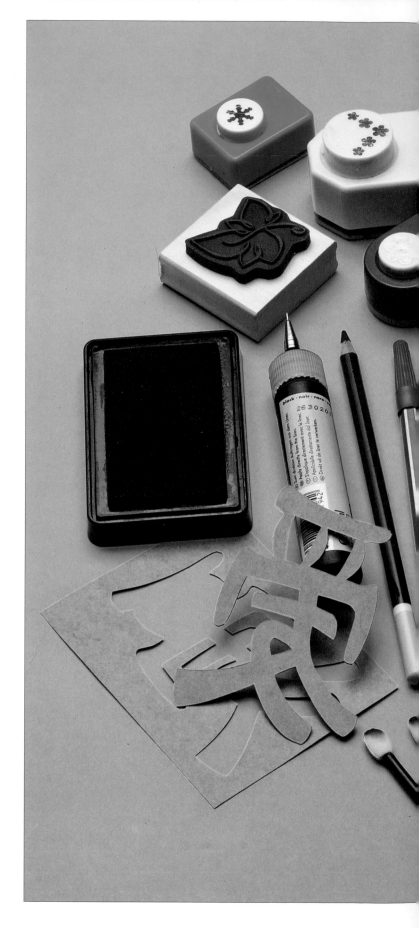

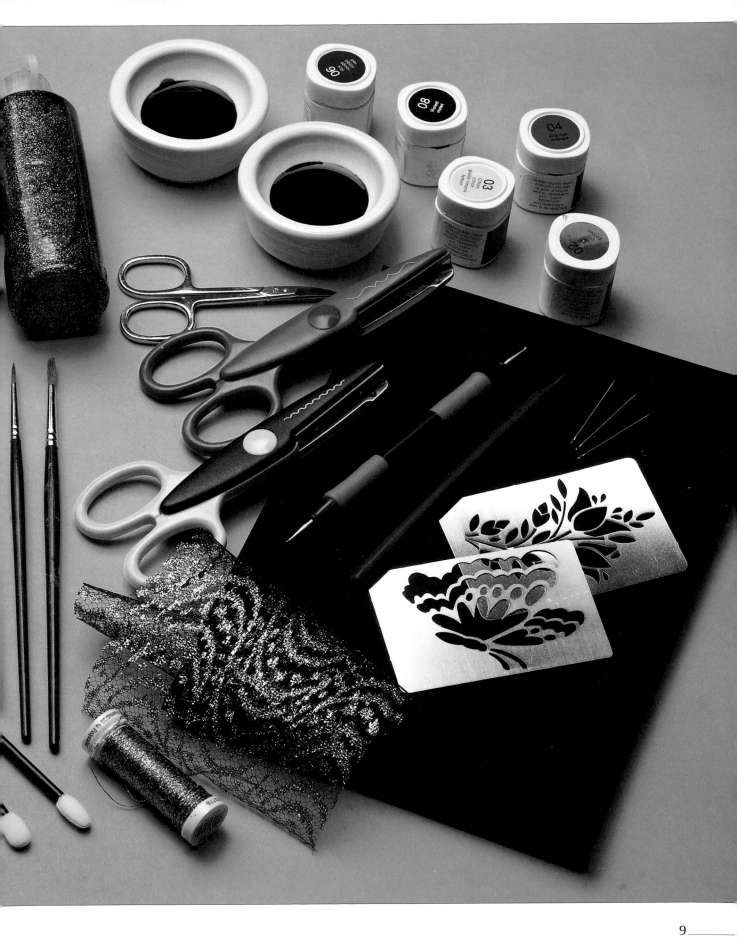

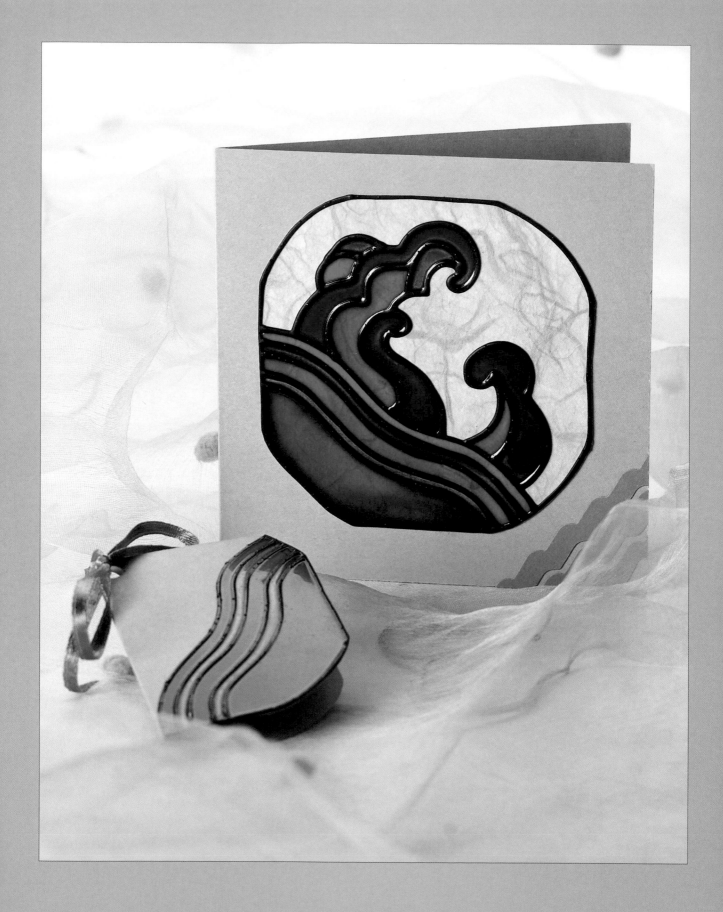

Waves and Water

Glass painting is a modern version of the traditional craft of creating stained glass windows, but we use acetate instead of glass and outline paste in place of lead. All of the necessary equipment is available from craft stores.

If you have never used the materials before, try some practice attempts first – the technique is not dissimilar to icing a cake. First secure a piece of acetate on top of the design. Put the smallest dot of paste on to the acetate, then lift the nozzle a little and allow the paste to fall on to the line. Move the tube carefully round the design while continuing to let the paste fall on to the drawing. This way you will have much more control, resulting in a clean line. When the outline has dried, you simply flood the different sections of the design with glass paint.

Outline stickers are a wonderful substitute for paste if you are in a rush or are not quite confident enough to use the paste. There are two examples on pages 14–15.

The Japanese word for wave is 'nami', and it features regularly in traditional and contemporary design and painting. This motif is taken from an heraldic crest.

YOU WILL NEED

Pale turquoise card blank 12 x 12cm (4¾ x 4¾in)

Thin, slightly darker turquoise card 4 x 8cm (1½ x 3¼in)

Sheet of acetate 13 x 13cm (5 x 5in)

Pale blue mulberry tissue 13 x 13cm (5 x 5in)

Cardboard 16.5 x 16.5cm (6½ x 6½in)

Tracing paper and two pieces of white paper 13 x 13cm (5 x 5in)

Pencil and ruler

Turquoise and blue glass paint and no. 4 paint brush

Sharp pointed scissors and wave effect craft scissors

Black outline paste with 0.7mm nozzle

Glue stick and low-tack sticky tape

Spray mount and mask

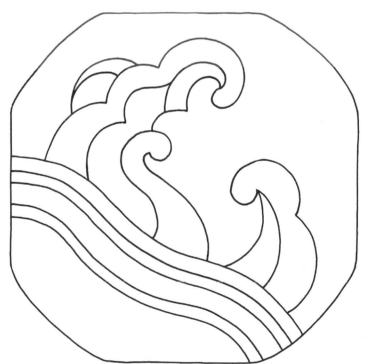

The template for the Waves and Water card, reproduced at actual size.

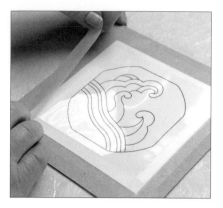

1 Transfer the design on to one of the pieces of white paper. Place the acetate on top, and use low-tack sticky tape to secure the paper and acetate on to the square of cardboard.

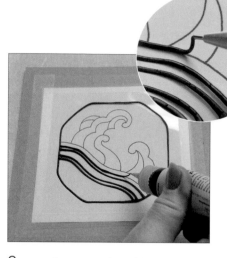

2 Pipe the outer edge of the design first, then the lines of water and finally the waves. Leave it to dry. The inset shows how far above the design the outline nozzle is lifted.

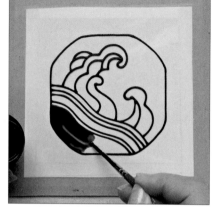

3 Flood each section with glass paint. Take care not to over-fill each area or leave brush marks as a result of too little paint. Leave to dry.

Tip
If you smudge or blob some of the outline paste while piping, leave it to dry and then very gently slice and scrape the excess away with the point of your craft knife.

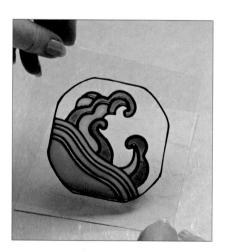

4 Using the spray mount, stick the mulberry tissue on to the other square of white paper, and then stick the design on to the mulberry tissue.

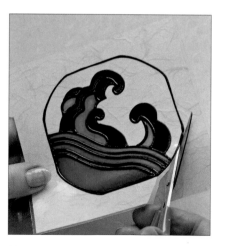

5 Carefully cut around the edge of the design using the sharp-pointed scissors.

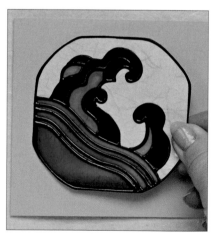

6 Spray the back of the design with spray mount and position the design 12mm (½in) from both the top and the left-hand side of the card blank.

 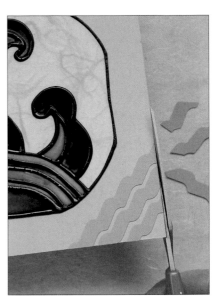

7 Draw four lines 6mm (¼in) apart on the smaller piece of turquoise card. Using the lines as a guide, cut three strips with the wave effect scissors.

8 Turn the strips over and attach them across the bottom right-hand corner of the card using the glue stick.

9 When they are dry, use the sharp-pointed scissors to trim the waves flush with the card.

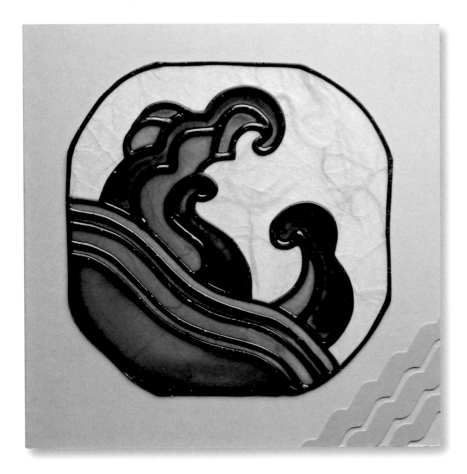

On formal occasions, Japanese families used to wear their own particular emblems. Over the centuries, many of these crests have evolved, some becoming simplified and others more complex; but they all retain the elegance typical of Japanese design. The gift tag (shown on page 10) takes the simplest elements of the design and positions them within the same shape as the card emblems.

Butterflies Fluttering By

Green and gold always work well together. Here I used outline stickers pressed on to acetate. I then painted the butterflies on the back of the acetate to avoid staining the gold sticker. The dark green handmade tissue paper has fine lengths of gold threaded through it. A circle cutter was used to make the gift tag, which was the inner section taken from the circle of the card.

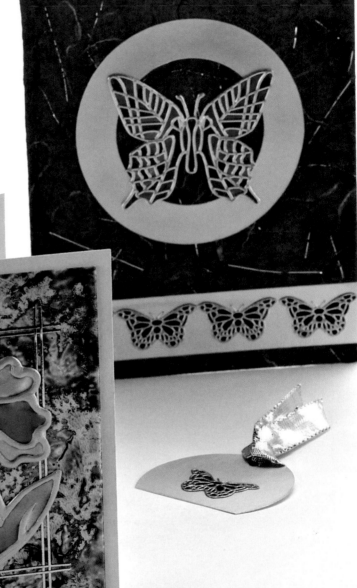

Perfect Peony

This marble effect was achieved by spreading glass paint on the acetate, allowing it to partially dry and then pressing another piece of acetate on top and immediately peeling it off. After piping and painting, the peony was glued on to white paper, cut out and then stuck on to the marbled acetate. Outline stickers were used for the border.

Silver Pagoda

*What good fortune to find these large and small pagodas in the form of outline
stickers. They were stuck on to acetate, flooded with glass paint and then painted
on the back with opaque white glass paint. This prevents the colour from being
visually absorbed by the black background. The little yellow symbol means 'luck'.*

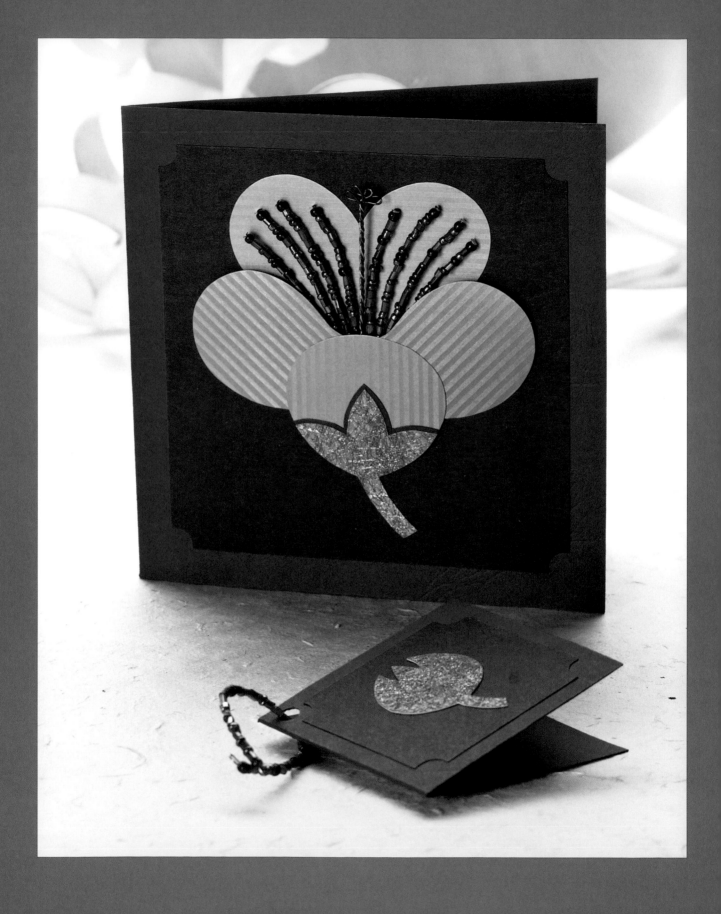

Plum Blossom

There is such a wonderful variety of pretty beads available now that it is often difficult to choose the appropriate ones to fit a particular design. Wire too has become an exciting material with which to work. I used to have to raid the tool box for little cards of fuse wire when I first started using it as an aspect of card making, but now it comes in different widths and glorious colours. When the two are combined – glittering, twinkling beads and twirling, twisting wire – a kind of magic is created in the finished card.

There are specialist shops where beads and all the associated materials can be bought, both online or mail order by telephone. They are also sold, though with limited variety, at many craft stores.

There are many variations on the plum blossom motif, and I have combined two to make this simple and effective card. Beads and wire are so versatile they can be guaranteed to enhance virtually any design as you can see on pages 20–21. Here I have used four different coloured wires and twisted them to form the stigma, along with eight beaded head pins to represent the stamens.

You will need

Red card blank 13.5 x 13.5cm (5¼ x 5¼in)

Plum-coloured paper or card 11.5 x 11.5cm (4½ x 4½in)

Craft scissors and curved cuticle scissors

Striped pearlescent copper-coloured card 15 x 15cm (6 x 6in)

Copper-coloured synthetic spun paper 5 x 5cm (2 x 2in)

Red card or paper 5 x 5cm (2 x 2in)

A5 tracing paper and pencil

Eight gold-coloured head pins

A variety of small red, burnt orange and copper-coloured beads

7.5cm (3in) lengths of pink, light red, dark red and copper wire

Two cocktail sticks

Sticky tape, glue stick and clear all-purpose glue

Small pliers and old scissors

Adhesive putty

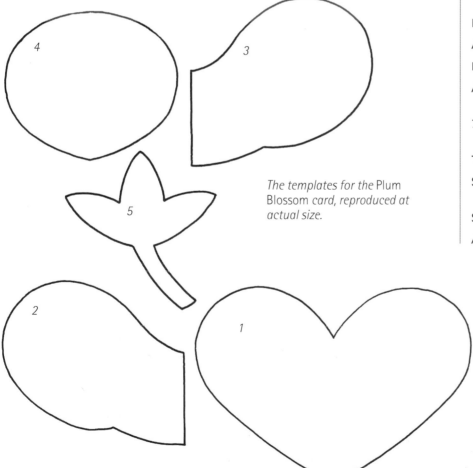

The templates for the Plum Blossom *card, reproduced at actual size.*

The template for the Plum Blossom *tag, reproduced at actual size.*

1 Using your craft scissors, cut the corners from the plum-coloured square. Stick it on the centre of the red card blank using the glue stick.

2 Transfer the blossom pieces 1, 2, 3 and 4 on to the pearlescent card. Using cuticle scissors, cut the pieces out. Stick pieces 2 and 3 together with sticky tape.

3 Glue the square of spun paper on to the pearlescent card using the glue stick. Press down firmly with some scrap paper and then leave it to dry.

Tip

If your pearlescent card is striped, make sure that the stripes are all going in different directions.

4 Transfer piece 5 on to the back of the spun paper and card, then cut it out. Transfer this piece on to the red card, cut it out and stick the two pieces together leaving a little red border at the top.

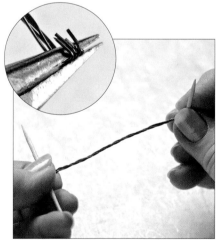

5 With the help of your pliers, hook each end of the coloured wires securely on to the cocktail sticks (see inset). Hold the wires and sticks firmly, then twist until you have a twisted strand.

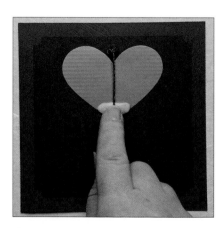

6 With the help of your pliers, pull out and flatten the top loops of the twisted strand. Use your old scissors to trim off any excess so that the wire stigmas measure about 6cm (2½in). Press the stigma into the adhesive putty.

7 Thread the beads on to the eight head pins. You may find that tweezers help when picking up small beads.

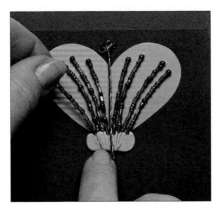

8 Bend each head pin slightly and position them as shown, pressing them into the adhesive putty.

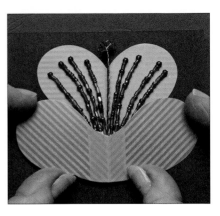

9 Squeeze some all-purpose glue on to the adhesive putty and then press pieces 2 and 3 on to it.

10 Stick the calyx on to the lower petal using the glue stick, then glue both of them on to the blossom.

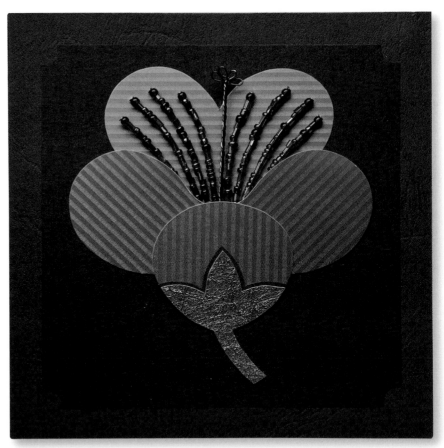

The subdued background colours on this card act as a perfect foil for the striped pearlescent blossom and the sparkling stamens and calyx. Cuticle scissors made cutting the rounded petals much easier.

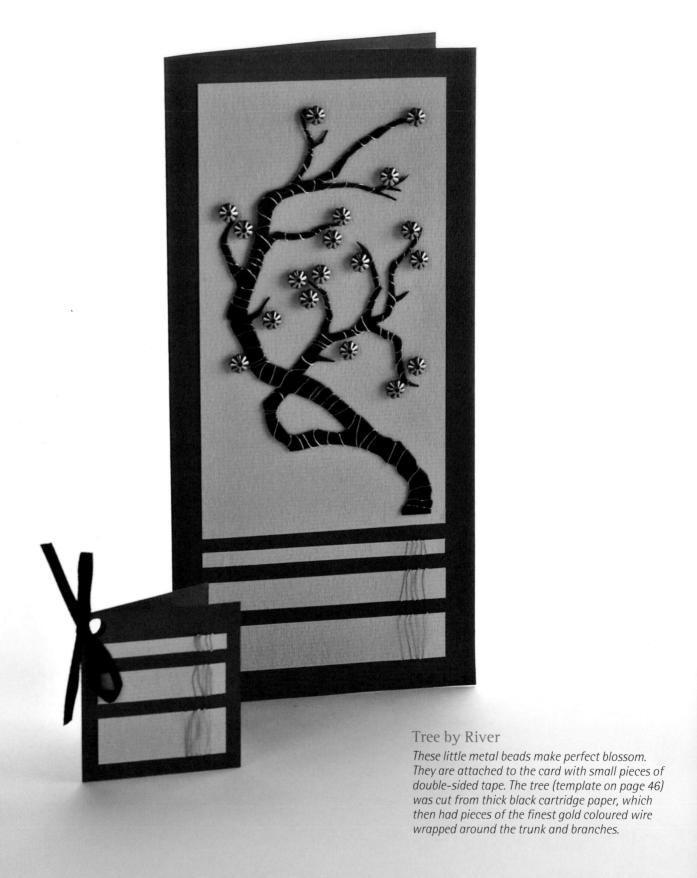

Tree by River

These little metal beads make perfect blossom. They are attached to the card with small pieces of double-sided tape. The tree (template on page 46) was cut from thick black cartridge paper, which then had pieces of the finest gold coloured wire wrapped around the trunk and branches.

Heron in Bulrushes

This was inspired by the well-known painting by Hiroshige, Bulrushes and Snowy Heron. *I have used straight pieces of wire to represent the bulrushes, a beautiful shark's tooth bead for the beak and a pearlescent flat bead for the eye. Everything is secured by double-sided tape. The Chinese symbol means 'happiness'. The templates are on page 46.*

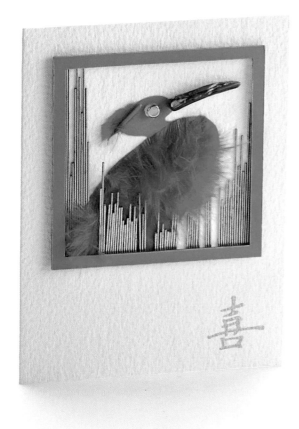

Flowering Circle

This was inspired by a circle of blossom from my book, Traditional Japanese Designs. *Diminishing lengths of black wire were threaded on to some stalks and, using double-sided sticky tape, the blossoms and buds were attached to others. The little pink beads were threaded on to cotton and the black beads were pressed on to a circle of black card using double-sided sticky tape. The template is on page 46.*

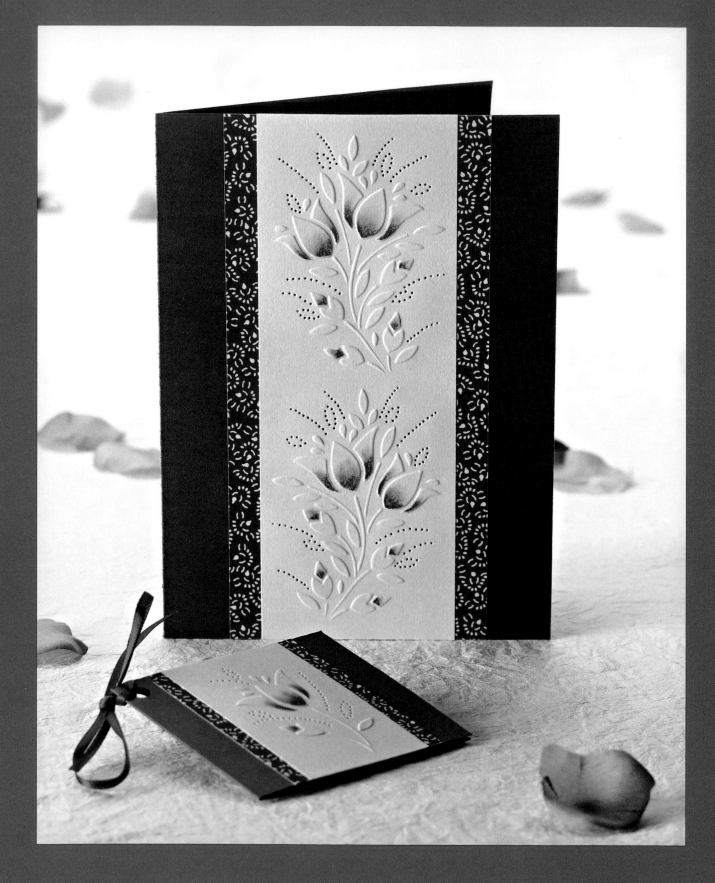

Flowers and Sparrows

Piercing, sometimes called paper- or pin-pricking, is a new craft for me and I have just discovered how effective and wonderfully versatile it can be.

Since the mid-1700s paper-piercing has been used to embellish pictures and paintings, usually in the form of a decorative border and to replicate the delicacy of lace, but sometimes to accentuate fine details on the paintings themselves.

The tools needed to complete a design are available at most craft stores. The needles, all with integral handles, come in different shapes to produce a variety of pierced holes. The mat is dense foam rubber, which allows the needles to slide smoothly in and out. Both sides of the pierced paper can be used; the underside gives a raised pattern of dots.

Embossing is the perfect companion to piercing. Small brass stencils (as well as larger plastic ones) have a comprehensive array of designs which can be imaginatively used. Brass stencils can also act as guides for piercing. Embossing tools come in about four sizes; the smallest ball tip is used for the most intricate stencil.

You may wonder where the sparrows are on this design. The little images on the pink paper are the sparrows. You can just make out their tiny heads and outspread wings. If you can't find a small-patterned Japanese paper, you could use gift wrap or even wallpaper.

YOU WILL NEED

Dark green card blank 13 x 16.5cm (5 x 6½in)

Small patterned Japanese paper 8 x 16.5cm (3¼ x 6½in)

White cartridge paper 6 x 16.5cm (2½ x 6½in)

Fine black and red felt-tip pens

Light box

Tracing paper and pencil

Steel rule, cutting mat and craft knife

Brass stencil with spray of flowers approximately 5 x 7cm (2 x 2¾in)

Single piercing needle and piercing mat

Embossing tool with small ball tip

Pastel pencil (same colour as patterned paper)

Small make-up sponge

Low-tack sticky tape

Spray mount and mask

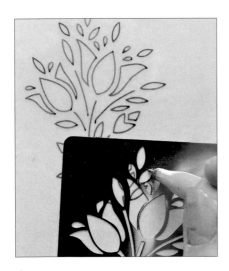

1 Lay the stencil on top of the tracing paper and draw the image using the black felt-tip pen. When the image is complete, move the stencil around and draw some extra leaves using the red pen.

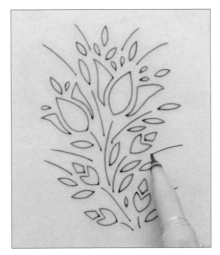

2 Remove the stencil and use the red pen to draws some curved lines coming out of the flower spray. Put the tracing to one side.

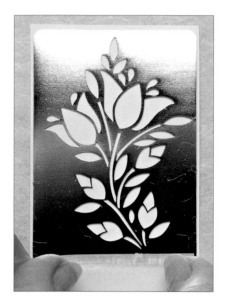

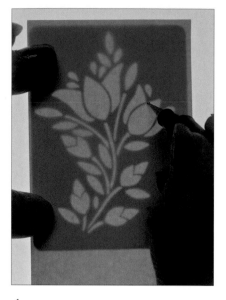

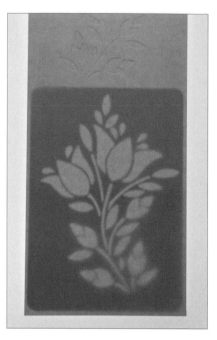

3 Position your stencil on the top half of the white paper. Secure it with a piece of low-tack sticky tape.

4 Place both the stencil and the paper on to the light box, with the stencil face-down underneath. Carefully but firmly slide the embossing tool round the edges of each shape.

5 Remove the stencil and turn it over so that the image is reversed. Position it on the lower half of the paper. Turn the paper over on to the lightbox and emboss the image as before.

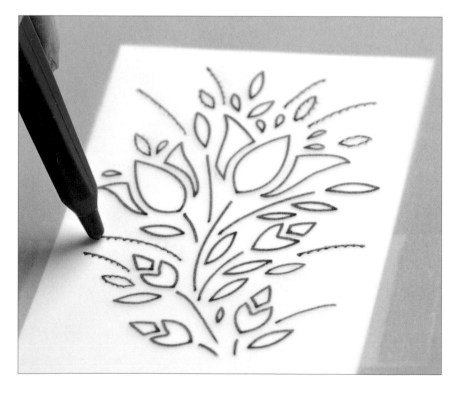

Tip

If the ball of your embossing tool does not slide easily on the paper, rub the tip on your hand or on some waxed paper. This should make it glide smoothly round the edges of your stencil.

6 Position the tracing accurately on top of the embossed image and secure it from behind with low-tack sticky tape. Use the piercing needle to prick along all the red lines, trying to achieve even spacing between each dot. Push the needle in as far as it will go to get the maximum size of hole.

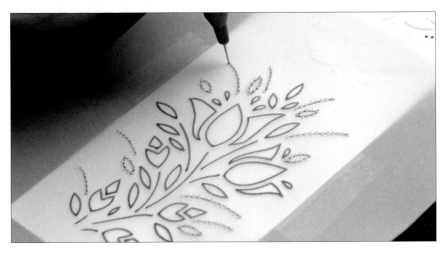

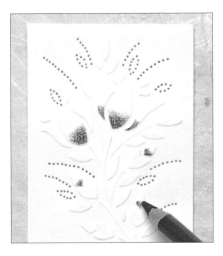

7 Remove the tracing, turn it over and place it on top of the lower embossing. Secure it with low-tack tape. Pierce through the same holes as before to create a mirror image of the top embossing.

8 Carefully apply the pastel pencil to the base of each petal and bud.

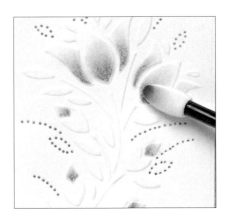

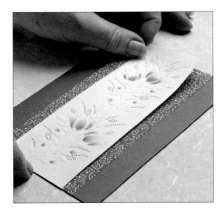

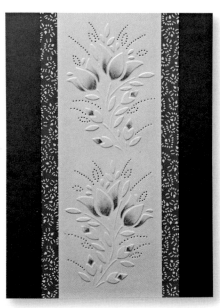

9 Smudge upwards with the make-up sponge to soften the colouring.

10 Using the spray mount and mask, attach the patterned paper down the centre of the green card, then attach the embossed paper down the centre of the patterned paper.

This pretty card demonstrates how well the two crafts of embossing and piercing complement each other. On the patterned paper the sparrow images have been simplified in typical Japanese style, and reduced to tiny defined heads and rows of elongated dots which represent open wings.

Gracious Geisha

This lovely drawing was taken from my book, Traditional Japanese Designs. I have adapted her to fit the card and pierced the image using round and arrow-tipped tools. The hairpin embellishments are made from jewellery head pins, threaded with small beads which were then secured with sticky tape at the back. You can photocopy the drawing on page 46 and use it as a piercing template. The Chinese symbols mean 'woman' and 'beauty'.

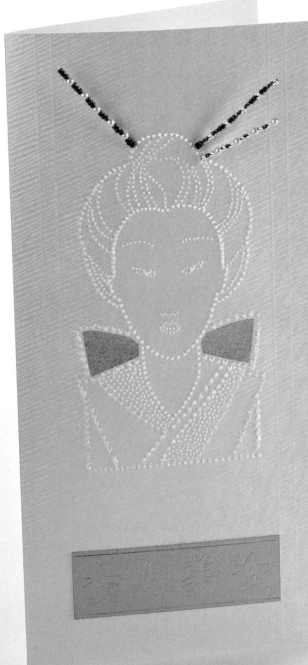

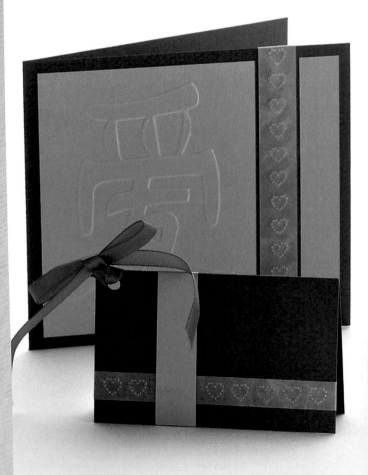

Lovely Love

Heavy tracing paper was pierced with a heart-shaped piercing needle to produce the vertical strip on this card. I cut the stencil with waxed paper – the symbol means 'love'. See page 46 for the symbol template.

Beautiful Butterflies

I have used another small-patterned Japanese paper for this card, and a disc cut out using craft scissors to replicate the circles on the paper. I used a brass stencil to create the butterfly and pierced it to accentuate some of the detail. The little flowers were made using craft punches.

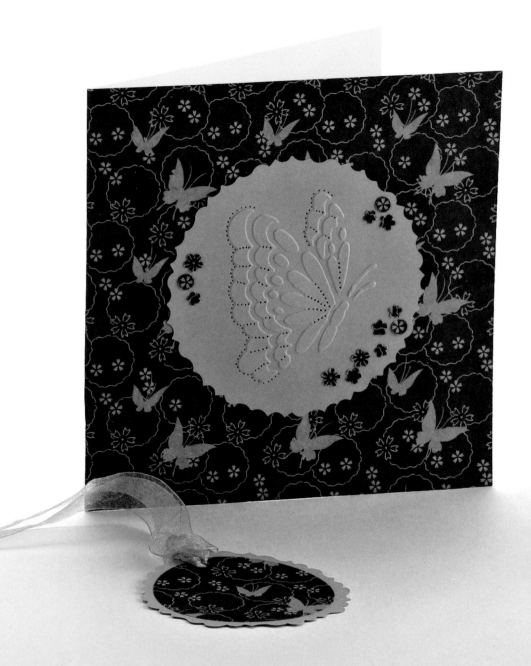

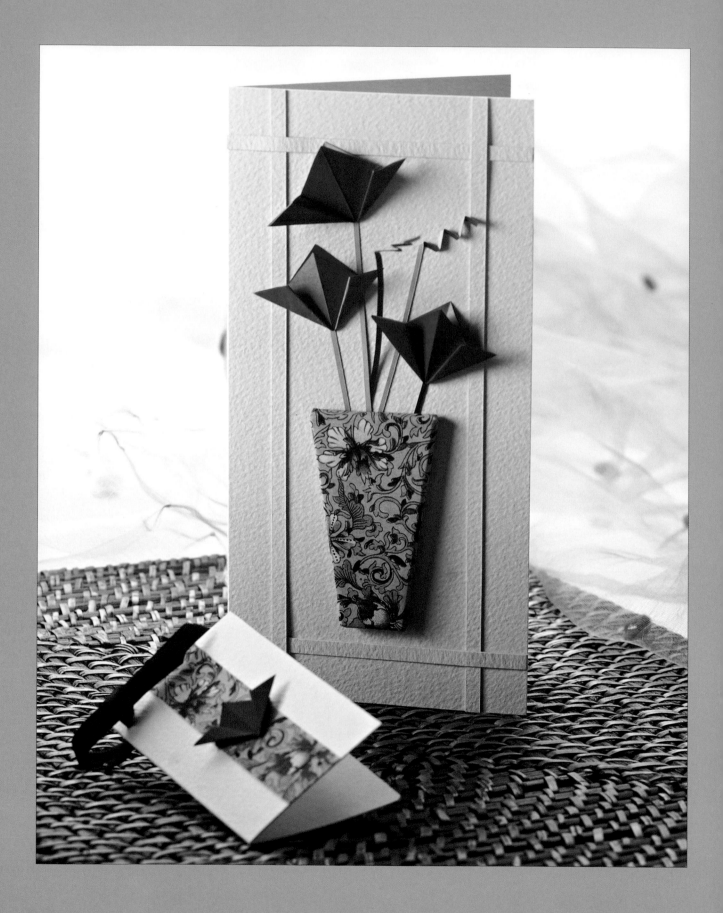

Formal Flowers

Origami is the Japanese word for paper folding and the art is closely connected to religious and cultural festivals, gift-giving and the craft of doll making. The production of paper was developed by the Chinese and adopted by the Japanese in 700AD. There are examples of paper folding dating back to 1000AD.

Origami is a simple concept but many of the designs are fiendishly complex and require great patience and dexterity. Here however, I have included little models that require only three or four folds in order to become recognisable. Even with such simple moves there is a great sense of achievement on completion – at least there was for me!

The thin but strong paper used for origami can now be found in many craft stores. There are packets of square sheets with different small-patterned papers, papers with a different colour on the reverse side and single-patterned papers in a multitude of bright colours. Wrapping paper, tissue paper and computer paper can all be used, and if the papers are thin enough, it is possible to glue them together to make a double-sided paper.

I have used double-sided origami papers to make the little flowers and stems in this project. The delicate Chinese pattern for the vase was originally on a surface-enamelled copper bottle. I scanned the pattern, changed the colours and then printed it; but any paper with a small ornate pattern will be fine.

YOU WILL NEED

Cream card blank 10 x 12cm
(4 x 4¾in)

Two strips of cream card 0.5 x 10cm
(¼ x 4in)

Two strips of cream card 0.5 x 20cm
(¼ x 7¾in)

Patterned paper 6 x 9cm
(2¼ x 3½in)

Two pieces of cardboard 4 x 7cm
(1½ x 2¾in)

Two double-sided origami papers
15cm (6in) square

Craft knife and cutting mat

Pencil and steel ruler

Double-sided tape and glue stick

1 Using the glue stick, position the cream strips 15mm (½in) from the edges of the card, laying one on top of the other at each corner.

2 Glue the two pieces of cardboard together. Use the pencil to mark, and then use the craft knife and steel ruler to cut along the two long sides so that they taper to 2cm (¾in) at the lower edge.

3 Lay the shape on the patterned paper and fold and stick the edges down with the glue stick, as though wrapping a present.

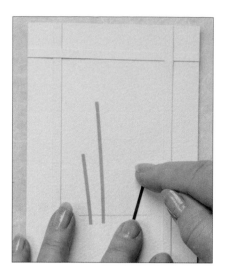

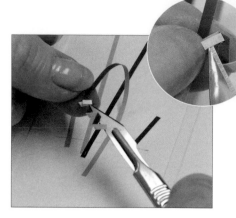

4 Draw a faint line just below half way down the card. Cut five narrow strips of double-sided paper – 4cm (1½in), 7cm (2¾in), 2.5cm (1in) and two 10cm (4in) long. With a dab of glue at both ends, position three strips, each attached slightly below the pencil line.

5 Make five concertina folds at the top of the two remaining strips, creasing first one way, then the other, as shown.

6 Position the two remaining strips on the card. Use a dab of glue at the bottom, and the tiniest sliver of double-sided sticky tape on one of the folds to secure the top. Use the craft knife to remove the backing from the sticky tape (inset).

Tip

Sometimes, if your paper is doubled, it is easier to initiate another fold by using a thin, straight-edged implement like a ruler. Position the ruler where the crease is to be made, lift the paper up and press it against the edge of the ruler, then remove the ruler and press down the paper to make the crease.

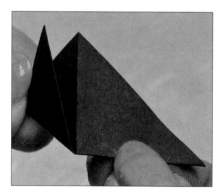

7 Cut two 4cm (1½in) squares from the double-sided paper. Fold the first square diagonally, point to point.

8 Open the square of paper up again and repeat with the other two points.

9 Fold the corners into the middle as shown.

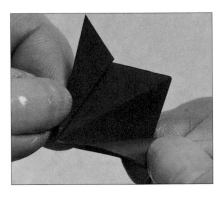

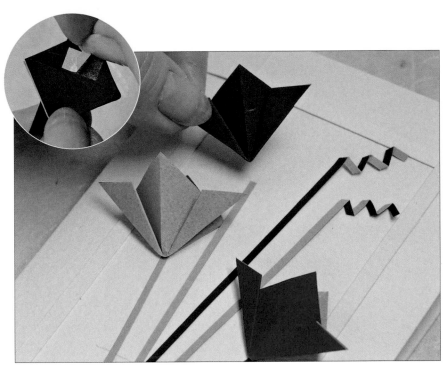

10 Fold the corners out so that the two edges meet as shown, then make another flower in a different colour by starting on the other side of the paper. Make a third flower by following steps 7–10 with a different piece of double-sided paper.

11 Attach a piece of double-sided sticky tape to one side of the back of each flower (inset), then position them at an angle on the card.

12 Glue the vase and position it 6mm (¼in) above the bottom cream strip to finish.

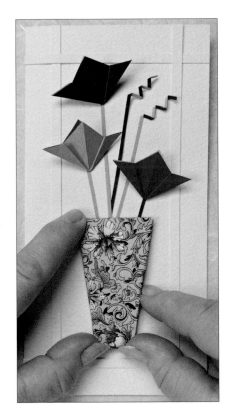

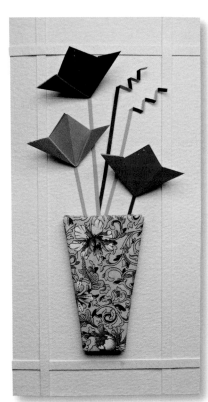

These little origami flowers are created by only four folds of a square of paper. The paper is double-sided so that the inside colour of the flower is different from the outside. The ornate pattern on the vase complements the simplicity of the flowers and stems.

Fine Little Fans

These are made from concertina folds. Using a pencil I lightly marked the measurements out for each fan and then used a brass stencil to assist with the creasing. The fan ties are made from unravelled string and the little metal emblem (which means 'beauty') is cut from a foil take-away dish (a template can be found on page 47). The card itself is a lovely handmade paper.

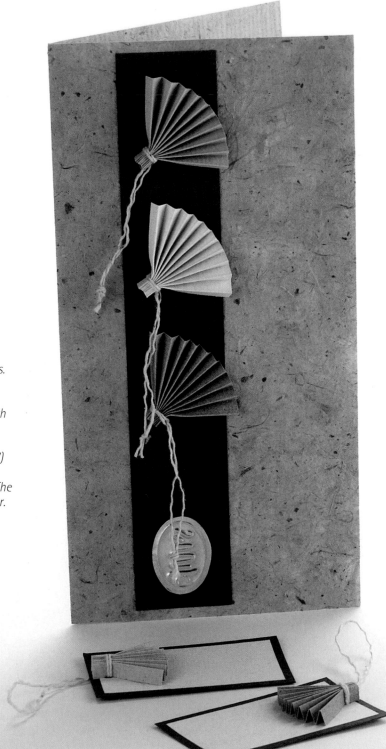

New Home

The instructions for making the little house are on page 47. The roof pattern on this double-sided paper resembles bamboo basket weave and is derived from a Buddhist symbol meaning 'happiness' or 'benevolence'. The background print is another Japanese small print called 'scattered petals'. The symbol in the top right corner simply means 'residence', but the card could be used as a 'welcome to your new home' greeting.

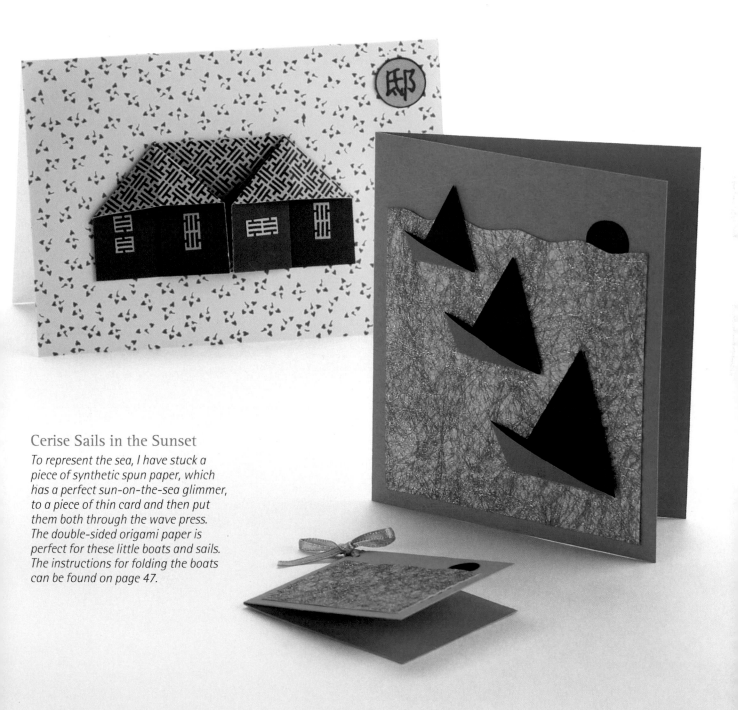

Cerise Sails in the Sunset

To represent the sea, I have stuck a piece of synthetic spun paper, which has a perfect sun-on-the-sea glimmer, to a piece of thin card and then put them both through the wave press. The double-sided origami paper is perfect for these little boats and sails. The instructions for folding the boats can be found on page 47.

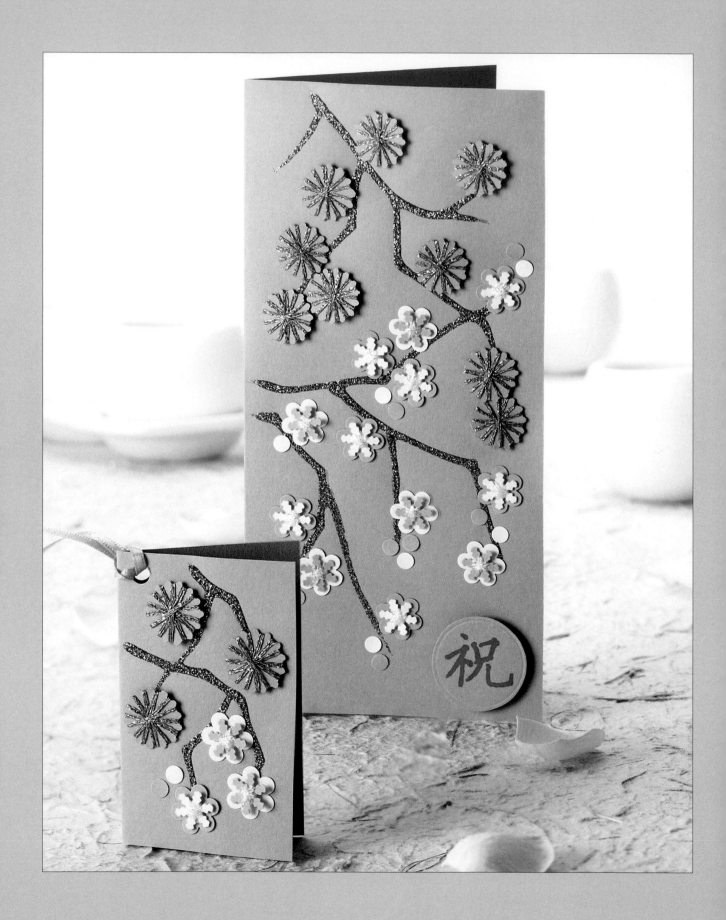

Pine and Blossom

Spirelli, from the word spiral, describes the craft of winding a thread round a notched template. The results appear to be very intricate but the process is really easy; and with all the fabulous threads available and a little imagination it is possible to create stunning cards. The basic process is to choose a shape, cut small 'V's or slits (depending on the thickness of the thread) at regular intervals round the edge, attach a piece of thread to the back, then wind the thread round the front and back securing it in the small cuts.

Commercial templates can be bought and you may want to start with them, but it is possible to make your own – just remember that there always needs to be an even number of cuts.

This design was inspired by a line drawing from my book *Oriental Flower Designs*. Pine and blossom are recurring subjects in Japanese design and painting, and they complement each other perfectly in form and colour. The Chinese lettering in the corner simply means 'good wishes'.

YOU WILL NEED

Blank grey card 10 x 21cm
(4 x 8¼in)

Pink and white card 10 x 10cm
(4 x 4in)

Grey card 18cm (7in) square

Tracing paper and pencil

Midnight sparkle glitter glue

Green felt-tip pen

Hole punch

Snowflake and flower craft punches

Glitter braid and fine green glitter
thread

Sticky tape, double-sided sticky tape
and double-sided sticky pads

Scissors, cuticle scissors and serrated
craft scissors

Tweezers, craft knife and cutting mat

Compasses or circle templates

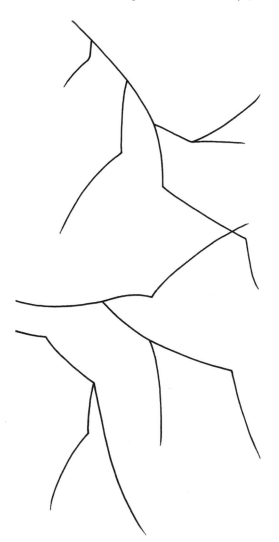

The template for the Pine and Blossom *card, reproduced at three-quarters of actual size. You will need to photocopy this template at 133 per cent for the correct size.*

Tip

If you have not use glitter glue before, practise a few lines first, keeping the nozzle slightly above the card, then lowering it and pulling away quickly at the end of each branch. An elastic band around the glitter glue tube and the attached nozzle will keep the nozzle cover out of the way while you are piping.

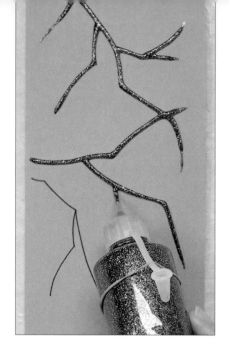

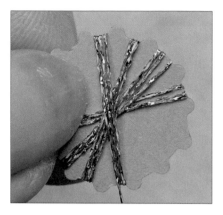

1 Draw the branches on to the card with a pencil and then start piping with the glitter glue. Leave for a few hours until the glue has dried and flattened.

2 Draw nine circles 17mm (⅝in) in diameter. Cut them out using your serrated craft scissors, making sure that there are an even number of notches on each.

3 Attach the green thread to the back of the circle using a small piece of sticky tape. Pull it over the front and round the back three times between two opposite notches, before moving clockwise one notch and repeating this action.

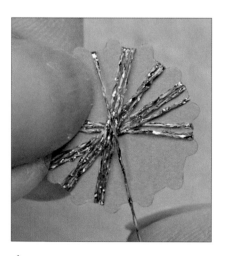

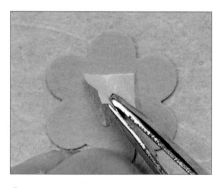

4 Continue working the thread clockwise all around the circle to make a pine symbol. Secure the thread at the back with sticky tape. Repeat this process with the remaining circles.

5 Punch seven pink and five white flowers using the flower craft punch; then seven white and five pink snowflakes using the snowflake craft punch; then, using the hole punch, seven white and seven pink circles, which will be buds.

6 Stick a square of double-sided sticky tape in the middle of a flower.

Tip
Tweezers make an excellent substitute for fingernails when working with tiny pieces.

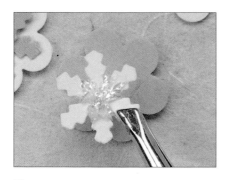

7 Put a piece of double-sided sticky tape on the back of a snowflake. Stick the glitter braid to it and wind it round the front and back of the flake spokes. This step is very fiddly, so use your tweezers: cut the braid and position the snowflake in the centre of the flower. Repeat with the remaining flowers.

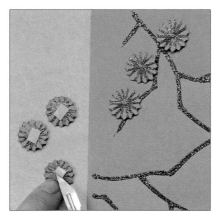

8 Place a square of double-sided sticky tape on the back of each pine symbol, and position them as indicated on the diagram.

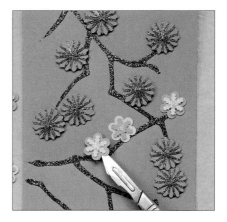

9 Place a square of double-sided sticky tape on the back of each flower and a tiny piece on each bud, and position them as shown below.

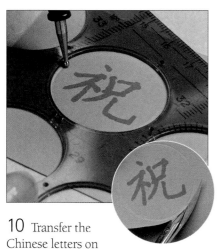

10 Transfer the Chinese letters on to a piece of grey card, then colour them with the green pen. Using the circle template and the embossing tool, emboss a circle round the letters. Carefully cut around the circle using the cuticle scissors (inset).

11 Attach four sticky pads to the back of the circle.

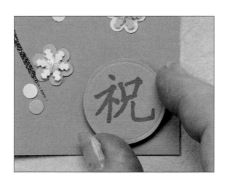

12 Position the circle on the bottom right of the card to finish.

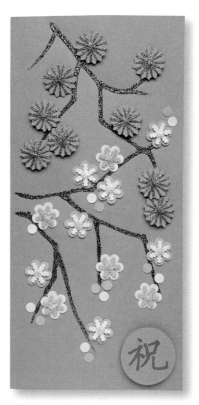

There is nothing better for drawing these branches than glitter glue, which is a great invention and very versatile. There is a knack to using it successfully that will become clear very quickly with a little practice.

Falling Leaves

I have used beautiful handmade tissue papers for the autumnal colours on this card. I took the shape from the leaf stamp (used all over as a pattern on the left of the card) and made three spirelli templates wound with copper-coloured thread. The Chinese characters in the bottom right mean 'autumn'. The template is on page 47.

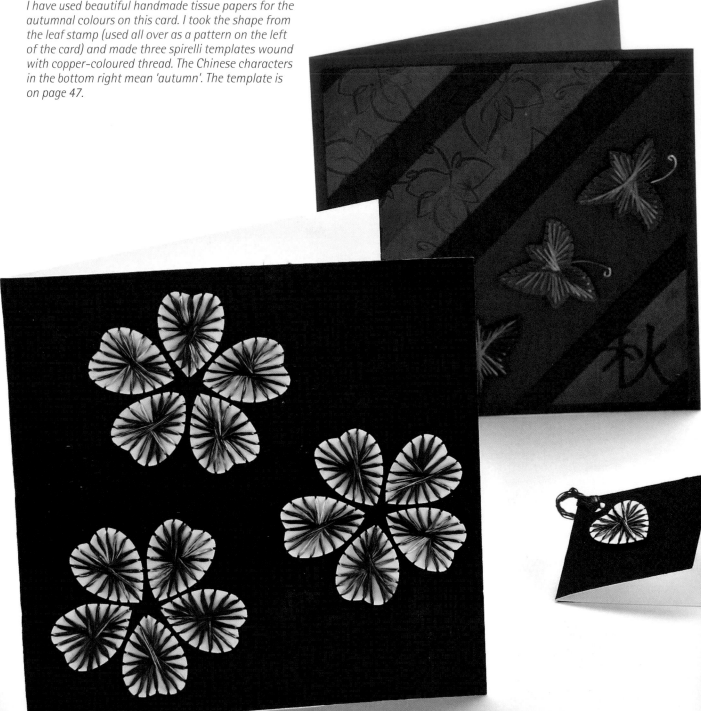

Sprinkled Cherry Blossom

These three blossoms were taken from a large print in which blossom images were tossed randomly to create an arrangement of negative and positive spaces. Here the arrangement is formal and the variegated silk thread produces a vibrant effect. The template is on page 47.

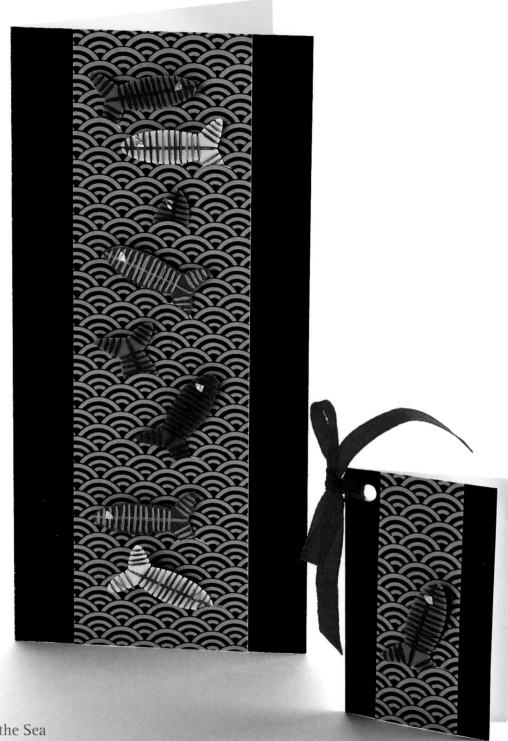

Goldfish in the Sea

This simple Japanese wave design called Waves from the Blue Ocean *was first used in the sixteenth century, then later as a decorative pattern on kimonos. I have cut some of the waves to accommodate the fish (template on page 47). These were secured at the back with sticky tape, and then the whole of the back of the card was covered with thin white card.*

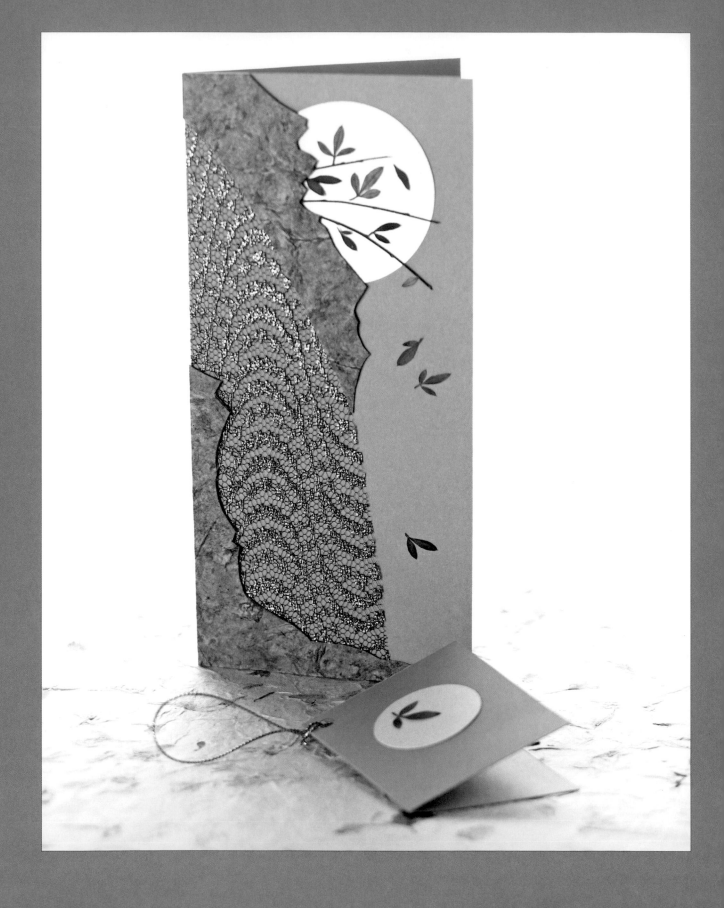

The Moon Beyond the Leaves

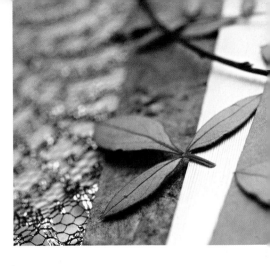

Collage: a picture made from scrap paper and other odds an ends; any work put together from assembled fragments. These are dictionary definitions, so really, with collage, anything goes. There are many books on the subject of Oriental painting, so you could choose one of the pictures that appeals to you, and then transform it by using any bits and pieces to represent the content or subject of the painting.

The Japanese artist Hiroshige (1797–1858) is a perfect example of an artist whose work can easily be developed using collage. One that I love, *The Moon Beyond the Leaves,* was the inspiration for this card. The title appealed just as much as the subject. I have used pressed leaves, but if you do not have any, you can simply cut some from one of the many lovely handmade papers available.

YOU WILL NEED

Blue card blank 10 x 21cm (4 x 8¼in)

White pearlescent card 8 x 8cm (3 x 3in)

Netting with wave-like pattern 10 x 23cm (4 x 9in)

Handmade textured paper 13 x 15cm (5 x 6in)

Three fine twigs and several small leaves

Tracing paper and pencil

Double-sided sticky tape and sticky tape

Sharp-pointed scissors, craft knife and cutting mat

Compasses and cuticle scissors or circle cutter

White scrap card for the rock and waterfall templates.

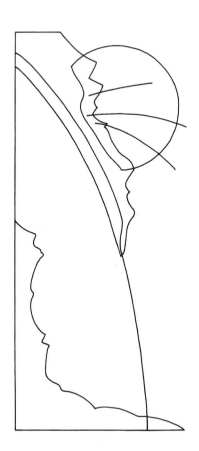

The template for The Moon Beyond the Leaves *card, reproduced at half of the actual size. You will need to photocopy this template at 200 per cent for the correct size.*

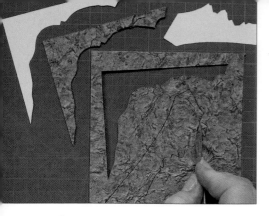

1 Transfer all the rock patterns on to card, cut them out and draw round the shapes on to the textured handmade paper. Cut each shape out with the sharp-pointed scissors; you may find it easier to use a craft knife.

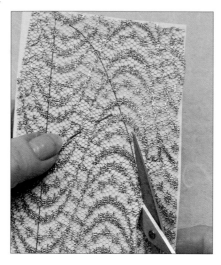

2 Transfer the waterfall pattern on to a piece of paper 10 x 23cm (4 x 9in). Pin the netting to the paper and use the sharp-pointed scissors to cut round the pattern.

3 Use a circle cutter to cut the moon out of the pearlescent card, then cut a segment off as shown above.

4 Place strips of double-sided sticky tape on to the blue card to secure the netting. Position the strips as shown so that they will be under the rock pieces.

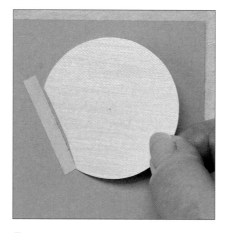

5 Stick the moon in position using double-sided sticky tape.

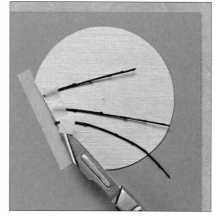

6 Use double-sided sticky tape to attach three twigs across the moon, but do not remove the backing yet. There will be a pinhole in the centre of the moon, so remember to cover it when positioning the leaves.

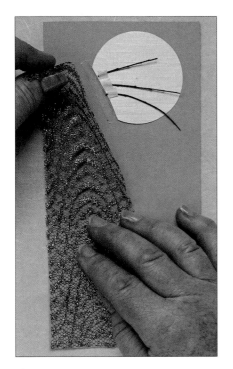

7 Place the waterfall netting, securing it on the double-sided sticky tape.

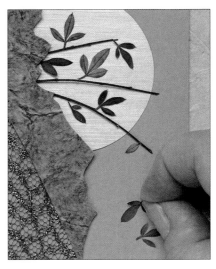

8 Remove the backing from the double-sided sticky tape securing the twigs. Put double-sided sticky tape on the back of the rocks and position them. Make sure the edges line up neatly with the edges of the card.

9 Sort through your leaves and position them on the branches. I find double-sided sticky tape the cleanest method of sticking small items; it is also preferable when gluing dried items. Position two or three leaves floating down by the waterfall to finish.

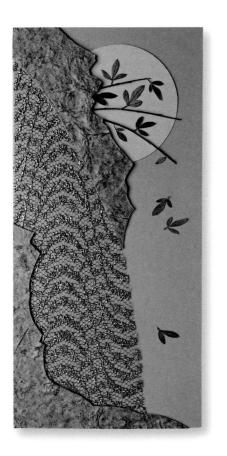

This is such a simple card to make. The silver and black net represents a waterfall; the rocks are cut from a random-textured handmade paper and the bits of twig are from the garden.

Copper Cockerel

The cockerel is one of the signs of the Chinese zodiac and features in many designs. Here I have used some gorgeous hairy knitting wool for the tail feathers and real feathers for the back and wings. The breast is a lovely embossed paper made from recycled papers and the head and feet are crinkled foil. The little beady eye is, of course, a little black bead. The Chinese symbol is a charm to ensure prosperity and long life.

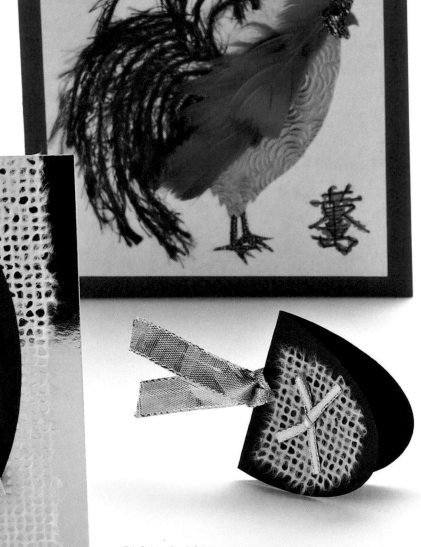

Girl in Gold Kimono

The kimono was originally an informal undergarment of the lower classes in Japan. Over time it developed into a costly outer garment and much importance was attached to its style and the quality, design and width of the fabric. Here I have used stiff ribbon for the kimono, ordinary ribbon for the obi (sash) and gold coloured wire for the hairpins. Everything is stuck on to a little model (see page 46) using double-sided sticky tape.

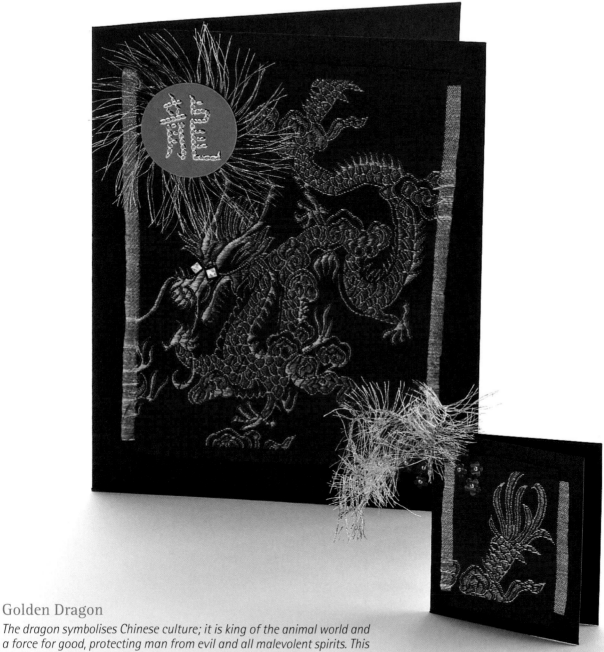

Golden Dragon

The dragon symbolises Chinese culture; it is king of the animal world and a force for good, protecting man from evil and all malevolent spirits. This glorious fabric was an off-cut that I frayed along each edge – the gift tag is the dragon's tail. The Chinese characters mean 'dragon' and are made from the little waste bits left behind when using outline stickers. The gold centres of the pink holographic flowers in the opposite corner are also dots left behind from sheets of outline stickers. The gold surrounding the orange disc is called 'soft drape feather garland' and the eyes are squares of gold holographic paper stuck on to squares of black card.

Templates

All of the templates on these pages are reproduced at three-quarters of actual size. You will need to photocopy them at 133 per cent for the correct size.

The templates for the Flowering Circle *card on page 21, right.*

The model for the Girl in Gold Kimono *card on page 44, lower left.*

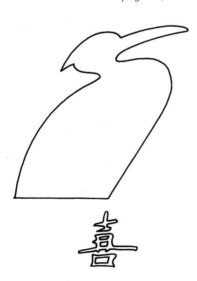

The template for the Tree by River *card on page 20.*

The templates for the Heron in Bulrushes *card on page 21, left.*

The template for the Lovely Love *card on page 26, right.*

The template for the Gracious Geisha *card on page 26, left.*

The template for the Perfect Peony *card on page 14, lower left.*

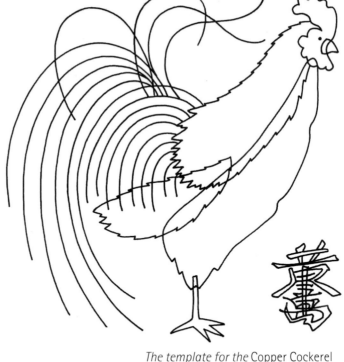

The template for the Copper Cockerel *card on page 44, top right.*

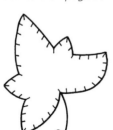

The template for the Goldfish in the Sea *card on page 39.*

The template for the Sprinkled Cherry Blossom *card on page 38, bottom left.*

The template for the Golden Dragon card *on page 45.*

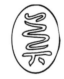

The template for the Fine Little Fans *card on page 32.*

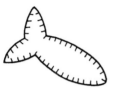

The template for the Falling Leaves *card on page 38, top right.*

The template for the New Home *card on page 33, top left.*

Folding instructions for the boats from the Cerise Sails in the Sunset *card on page 33, bottom right. Start with a square of paper and follow the numbered instructions below.*

1 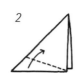 2 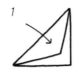 3 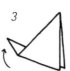 4 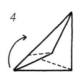 5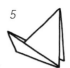

Folding instructions for the house from the New Home *card on page 33, top left. Start with a square of paper and follow the numbered instructions below.*

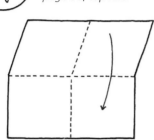 1

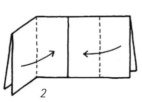 2 3 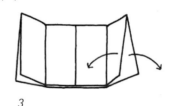 4

Index

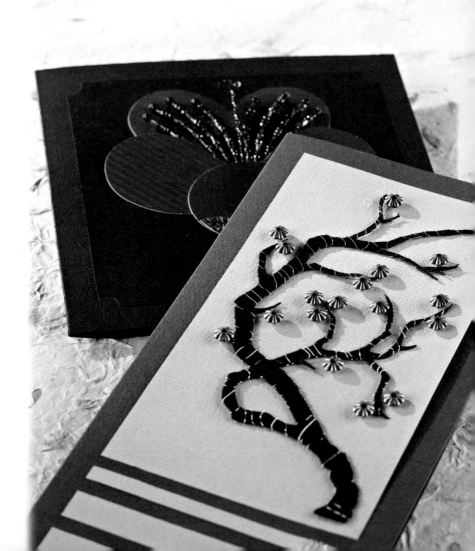